Soul Whispers

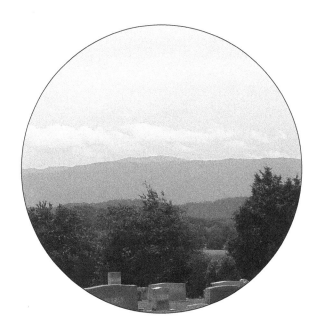

Praise for *Soul Whispers*

In her debut inspirational book of verse, Barbara J. Turner breathes her words and heart of healing and growth with grace juxtaposed with exquisite photographs that allow the reader to inhale and exhale, to "take time to nourish [our] spirit" while "peeling away layers" in our "search for truth." In each of these maxims, Turner offers up truths she has discovered in her own spiritual awakening that are universal in nature as we all "enter the grace of another day." *Soul Whispers: Listening to the Wisdom Within* celebrates living in a way each of us can understand, appreciate, and perhaps embrace as our own, all the while being uplifted and wrapped in comfort and peace. What a delight to read this beautiful book of inspirational verses. I shall indeed keep a copy by my bed for daily breathing.

—Sue Weaver Dunlap, author of *The Story Tender* and *Knead*

A luminous collection of images and words, *Soul Whispers* soothes and gently inspires while illustrating the splendor and wisdom available to each of us, in even the hardest times.

—Sonja Livingston, author of *Ghostbread*

In Barbara Turner's *Soul Whispers*, you will joyfully uncover profound insight into our human journey, with opportunities to deepen your contemplative moments. Along with visually appealing photographs, a book well-worth exploring and sharing.

—Lisa Soland, author and playwright

Soul Whispers

Listening to the Wisdom Within

Barbara J Turner

Barbara J Turner

ISBN: 978-0-692-05515-1

Cover photo: Barbara J Turner
Interior photos: Stefanie Stair
Creative consultant: Helen Mullins
Cover and book design: Beto Cumming

Printed in the United States of America

Mountain River Publishing
P. O. Box 394
Kingston, TN 37763

Soul Whispers is dedicated in memory
of the author's parents, Jay E. and Betty J. Wood;
to her father who instilled an appreciation
for ageless wisdom, while her mother's creativity
taught her how to express it.

PREFACE

I have been a seeker and I still am,
but I stopped asking the books and the stars.
I started listening to the teaching of my soul.
—Rumi

I believe there is ancient wisdom deep within that guides us if our heart is open to receive it. It is often that gentle nudging of intuition we feel when we must make a decision or when we face uncertain circumstances. Our inner voice speaks quietly, so we do not always hear it and, if we do, we're afraid to trust it, or we cannot distinguish it from the jumble of other thoughts.

Practicing how to listen to and trust my instinct is an ongoing process that I began when faced with personal upsets, similar to those many people experience. Whether caused by betrayal, job or financial loss, death or divorce, they break the hard shell we've built around our hearts. We become vulnerable as we navigate the uncertain waters of a new life. What we once held as truth is gone, shaking the foundation of everything we thought we knew, but the process itself often leads us to an awareness that improves our lives. According to Rumi, the wound is the place where the light enters you. This insight is never more apparent than when we are emotionally wounded.

Our vulnerability reminds us that lives once filled with special moments and treasured memories have turned into painful ones. As we process our pain, we feel suspended between dark and light, despair and hope. We either thrive or wither in those spaces between the dark and light of our lives. We begin

measuring time as years gone by rather than treasuring moments that make us feel alive. Ironically, it is in the silence of the space between dark and light where we hear the whispers from our soul for it is in that quiet place that we connect with divine intelligence.

For me, comprehension emerges through my writing as I uncover new concepts. As I write about the world around me, my observations inspire solutions to actions or decisions I must make. Getting to this place required a conscious, deliberate, and sometimes uncomfortable examination of my beliefs against what I thought to be Truth. As a result, I experienced a significant breakthrough. I had been searching for deeper meaning through talking about it with people I regarded as wiser than me, rather than tapping into what my soul already knew.

This realization became powerful in my search for understanding. I must access the wisdom within, and the way to do that is simple.

- Stay in the moment. Don't get ahead of what requires attention right now. If I attend to what this moment wants from me, the next one will take care of itself.

- Detach from the outcome. It is helpful to set a goal and have a plan, but I had to give up the expectation that things must work out in a certain way.

- Trust the synchronicity of life. I had to learn to have faith in such events instead of searching for their meaning before accepting their gift.

- Sit in silence. I must access the calm in my soul so the knowing within can surface.

Each aspect of this practice is valuable, but spending time in silence is essential to quiet the mind and create calm within. Finding that calm and then writing about my insights gave me the ability to discern between mere thoughts and soul wisdom. While this works best for me, there are many ways to reach the soul's calm; that place where insight already exists and where we connect with Spirit, our access to the Divine—the source of all knowledge.

Accessing this place can originate differently for others, such as viewing art in a museum, listening to a symphony, or observing the beauty of a snowflake in the sunlight. For this reason, I commissioned the images in *Soul Whispers: Listening to the Wisdom Within* to lend visual interpretations for readers to contemplate. The photos enhance the meaning in the poems and reveal that in the ordinary there is beauty; in dark, light; in storms, a rainbow, and in sadness, joy.

I invite you to discover personal meaning in *Soul Whispers* by reading its pages in consecutive order or by randomly opening to any verse for guided inspiration. And I hope this book reaches that place within that unlocks your heart to the whispers of wisdom that originate from your soul.

—Barbara J Turner

It is in the silence of the space between each breath that we hear the whispers of wisdom from our soul.

—Barbara J Turner

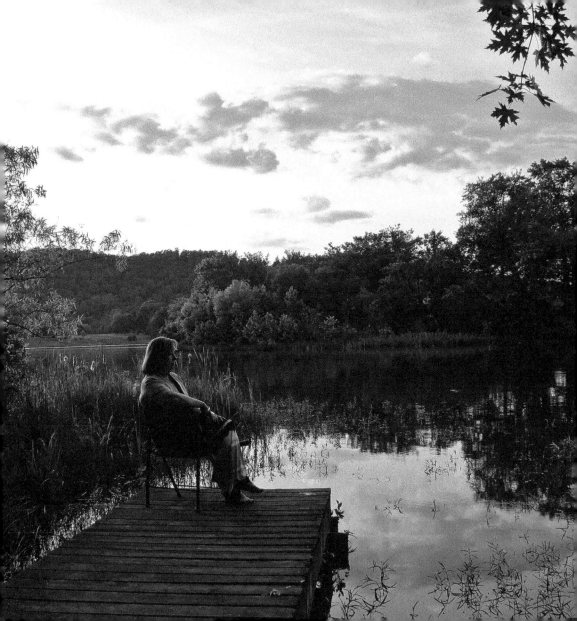

When I am still,

I am open to receiving

wisdom from The Universe.

It is in this solitude that I find

my way back from uncertainty

to the wisdom that already

exists within my soul.

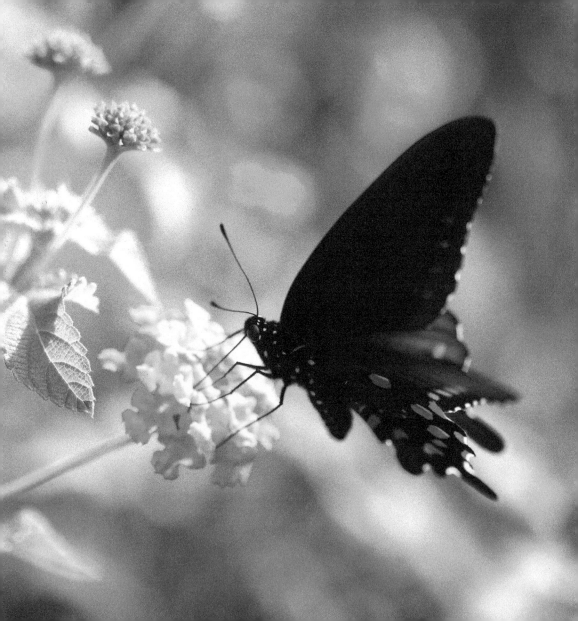

Writing from the truth

of my soul gives wings

to the words that resonate

within you.

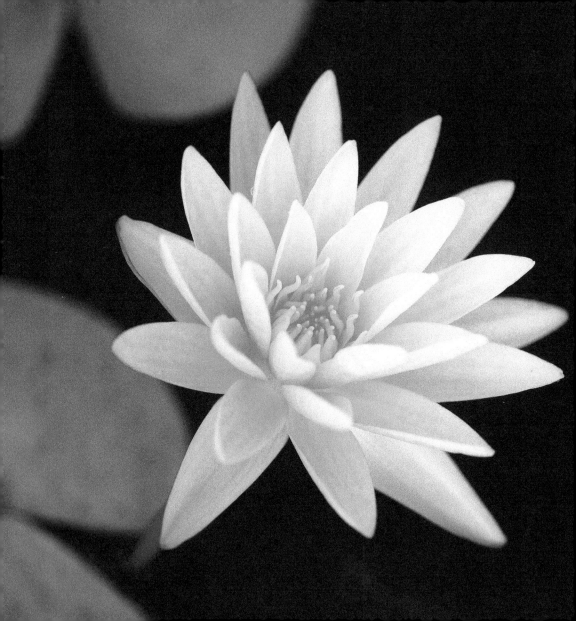

I must protect myself

from allowing the noise of life

to rob me of my inner peace,

which is the one thing

that gives me the courage

to face it.

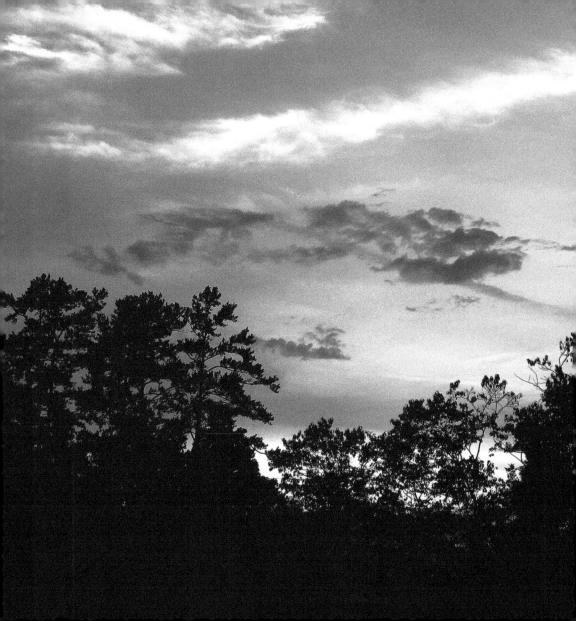

The chance to watch

the sunrise one more time

is a miracle of grace.

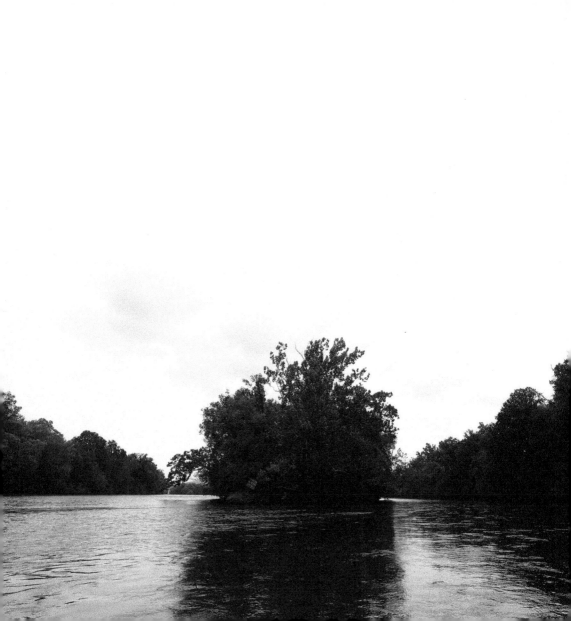

In a moment of clarity,

I realized I no longer needed

to understand why

something happened.

I have only to acknowledge

that it did for life

to flow freely again.

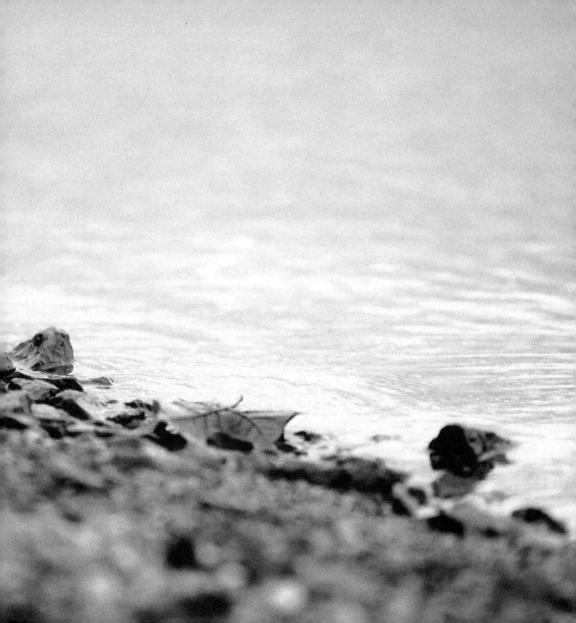

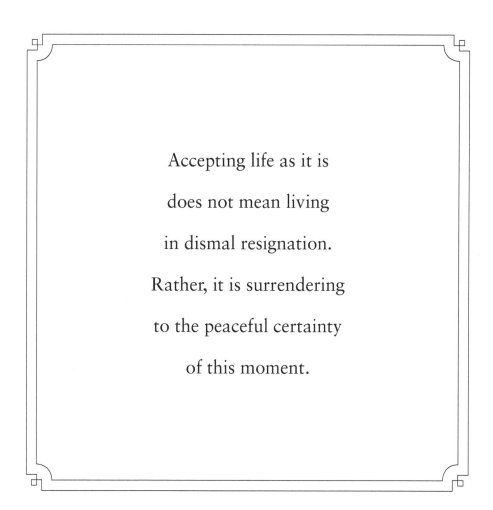

Accepting life as it is

does not mean living

in dismal resignation.

Rather, it is surrendering

to the peaceful certainty

of this moment.

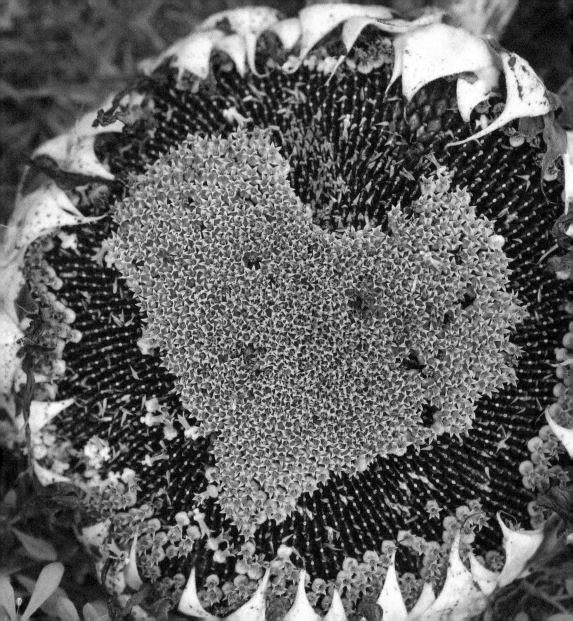

Opening our heart to love

also opens it to potential pain.

But if we live always protecting

ourselves from that possibility,

we have never really lived at all.

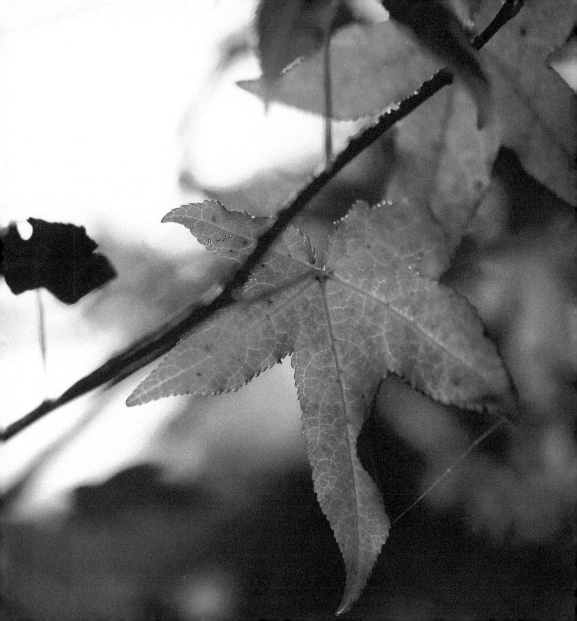

Imagine joyful feelings swirling

around you the way autumn leaves

do when a soft wind sets them free.

I hope you always feel

that joy in your heart.

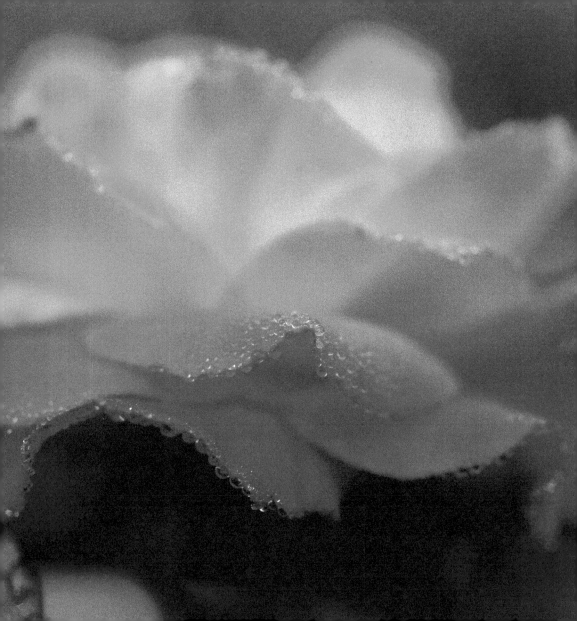

Trying to close a heart

that has been opened

by love is like trying to stuff

the petals of the rose

back into its bud.

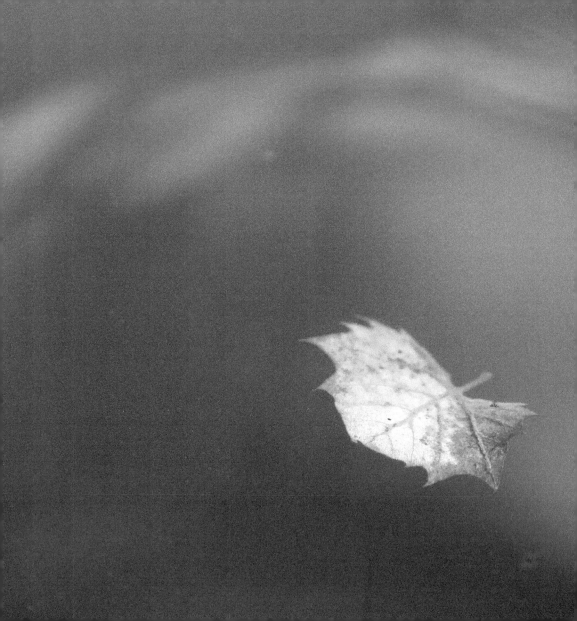

Taking a leap of faith

is different than diving

headfirst into murky waters.

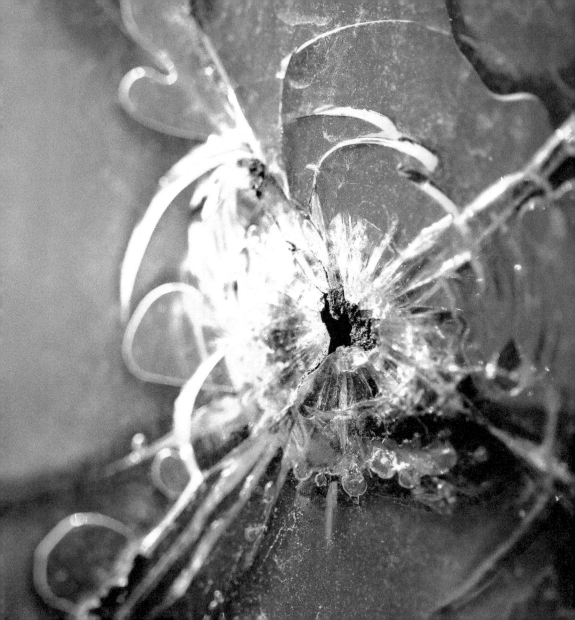

It takes courage

to walk over the shattered

pieces of a broken heart

to begin a new life.

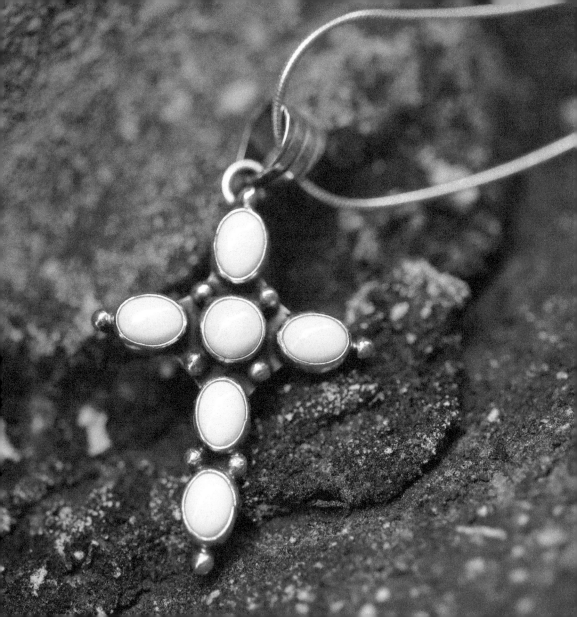

Sometimes things happen

that we don't understand

and never will. All we can do

is accept that it did,

honor what was good,

take a breath, and let it be.

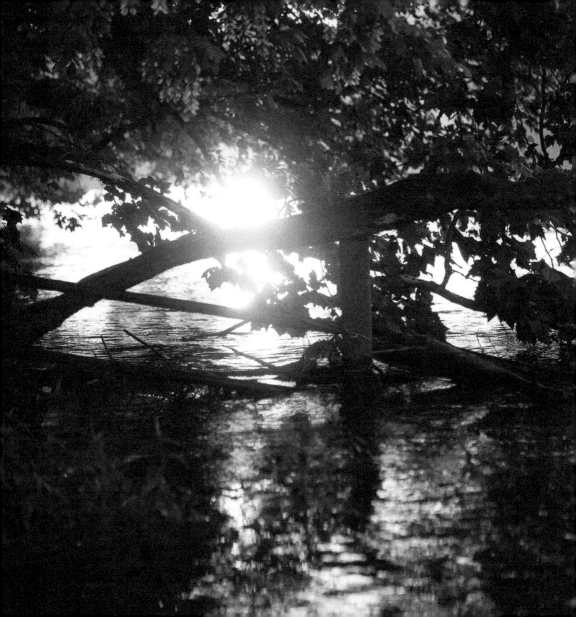

Just as waters of the stream

become rivers in the ocean,

the spirit of those we love

are part of us,

and their memory flows

through our soul, guiding

us with ageless wisdom.

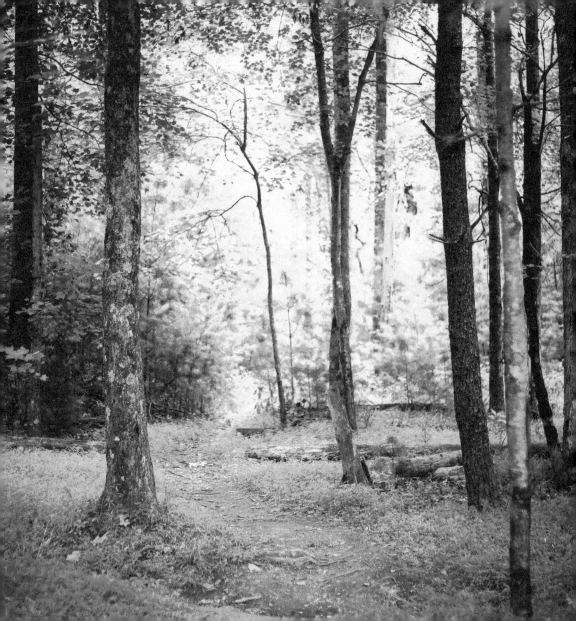

At any decision point

along the way, I might

have chosen a different path,

and I would have missed

having you in my life.

It is imperative

to choose consciously.

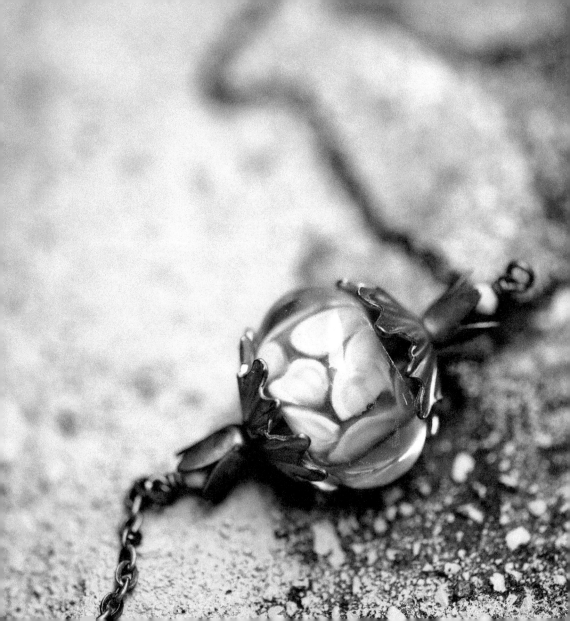

There are moments

that are jewels

for the senses,

like the light

in a friend's eyes

when she spots you

in a crowd.

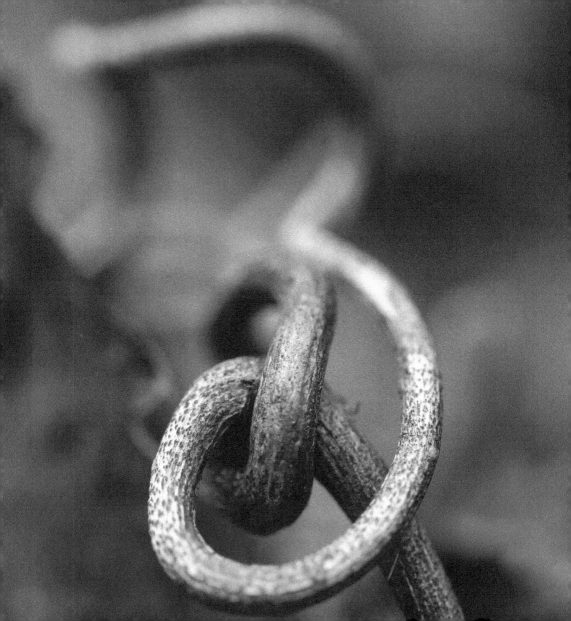

Every connection made

with another person reveals

a piece of the puzzle

that makes up the whole

of who I am, either adding

that which was missing

or taking away that

which does not belong.

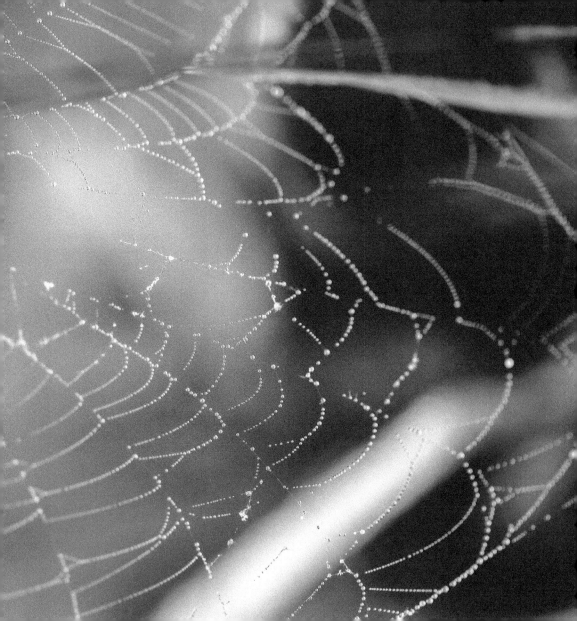

I realized that I am both

the cause and the cure

for things I don't want

in my life. I must not allow

myself to be trapped by a web

of my own making.

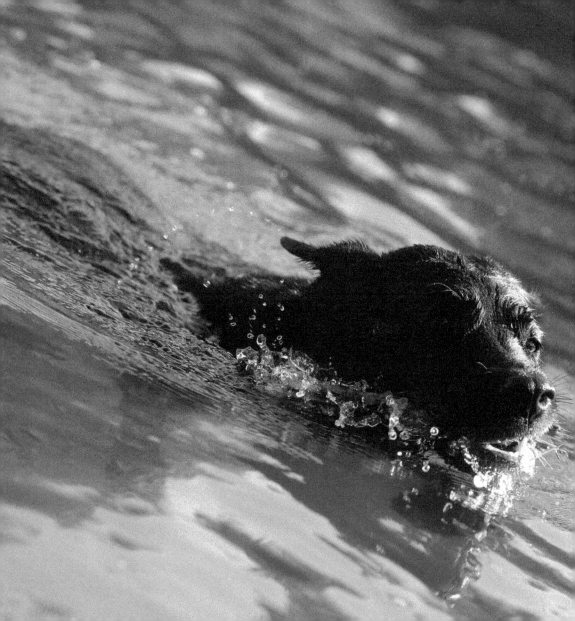

Some days are challenging.

For those days, I find a moment

or recall a memory that made me

feel alive and inspired

and hang on to that feeling.

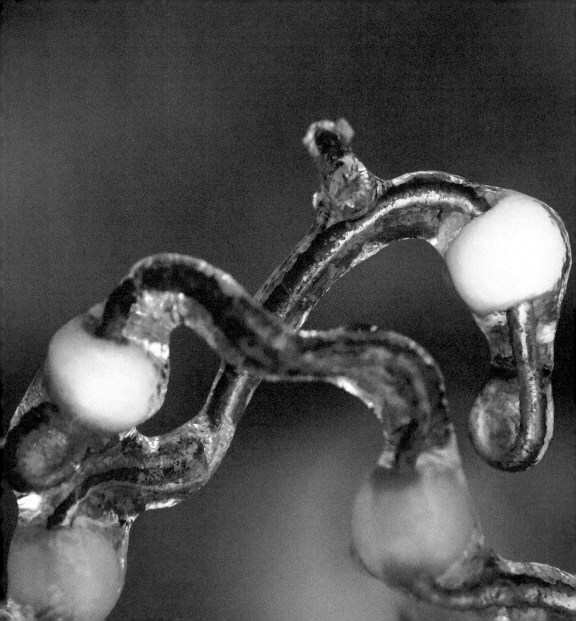

There are words frozen inside

my soul that long to be free, to find

their place in The Universe.

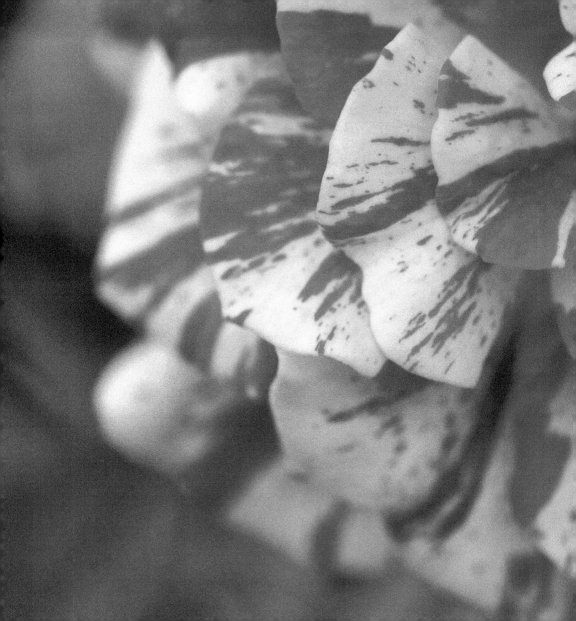

Our days are filled

with moments of beauty

that often get lost in the mundane.

Be aware of and savor

those special moments

for they are the treasures

of our memory.

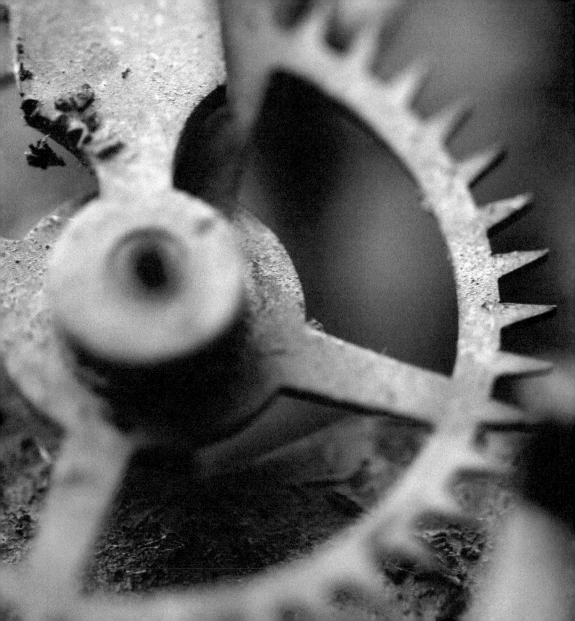

Decisions and life choices

that use only the mind

without considering

what the heart has to say

are like driving with the brakes on.

You can do it for a while,

but something will

break or burn out.

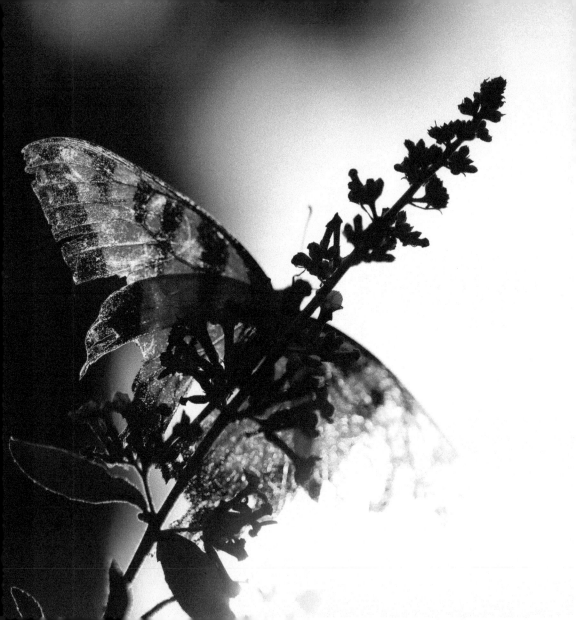

It is that first step

on a new path that moves us

out of the shadows of our doubt

and into the light of discovering

what feeds our soul

and renews our spirit.

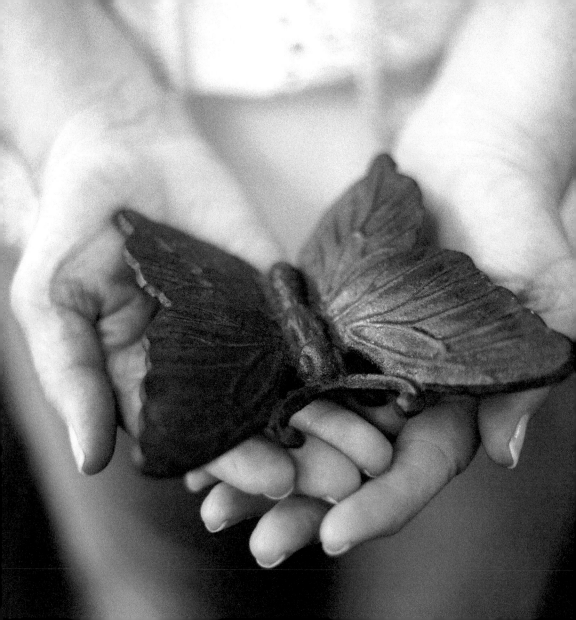

I am enough just as I am,

even in my brokenness

or maybe because of it.

So I threw away the self-help

books, said goodbye

to my inner critics,

and started living again.

That was the day I grew wings.

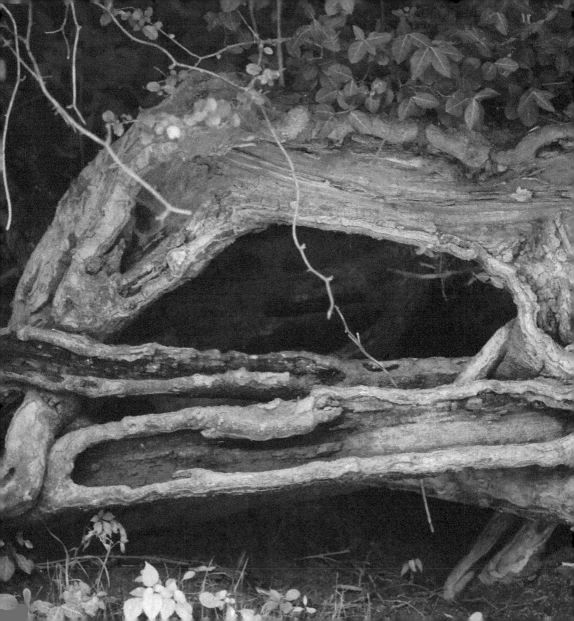

Listening to the longing

in the heart is different

than endless reliving of events

lodged in the mind.

The first leads to insight

that moves us forward,

while the latter keeps us stuck

in an inconclusive loop

of indecision.

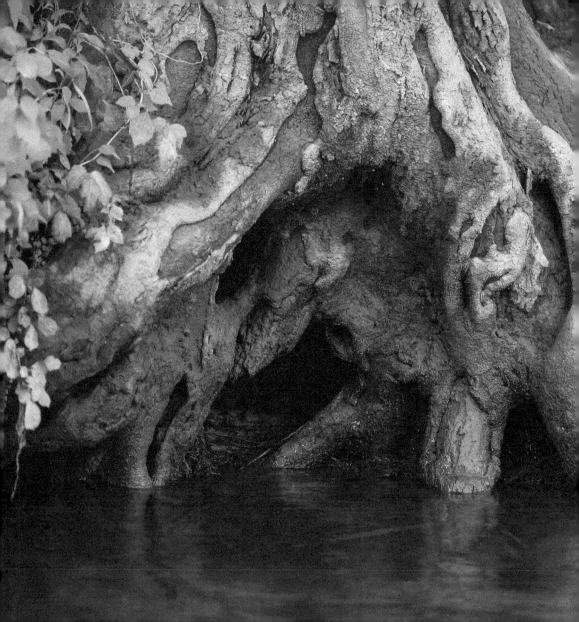

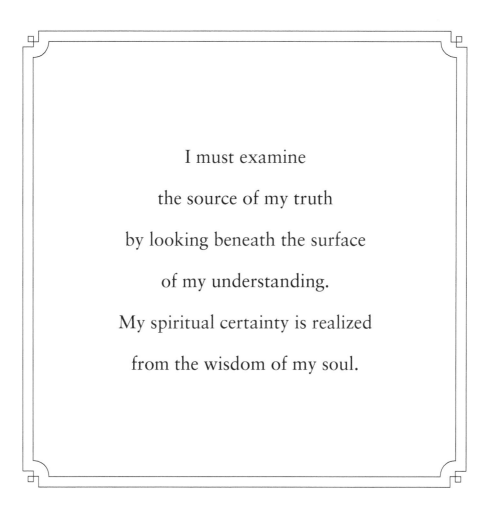

I must examine

the source of my truth

by looking beneath the surface

of my understanding.

My spiritual certainty is realized

from the wisdom of my soul.

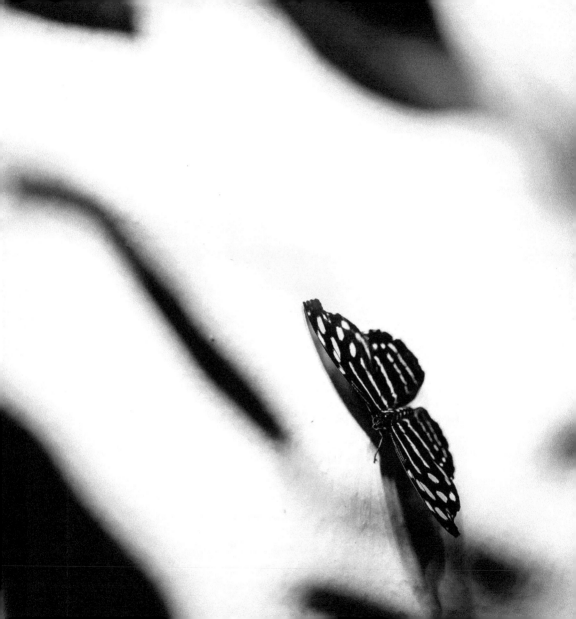

The point at which I realized

I had nothing left to lose

was the moment I knew

I had all I needed

to begin again.

In my search for truth,

I realized I had to start

with my own by peeling

away the layers under

which I have been hiding

my authentic self.

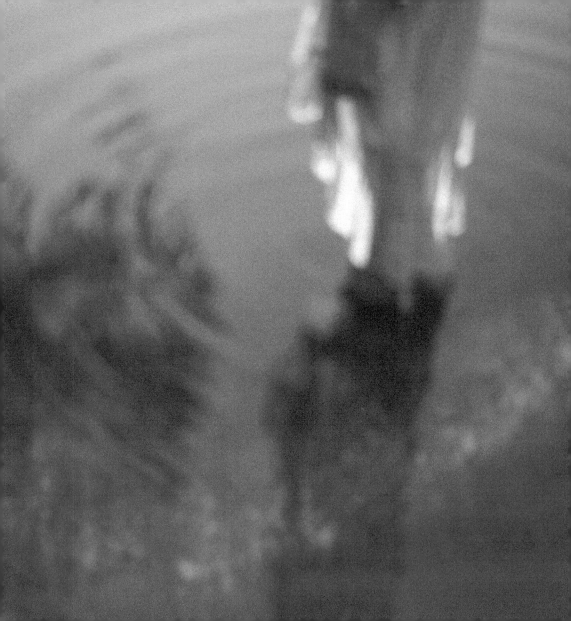

On the surface,

it appears we are alone

in our quest for life's meaning,

while underneath we are the same.

Our challenges may be different,

but we struggle in the same way

as we search for truth.

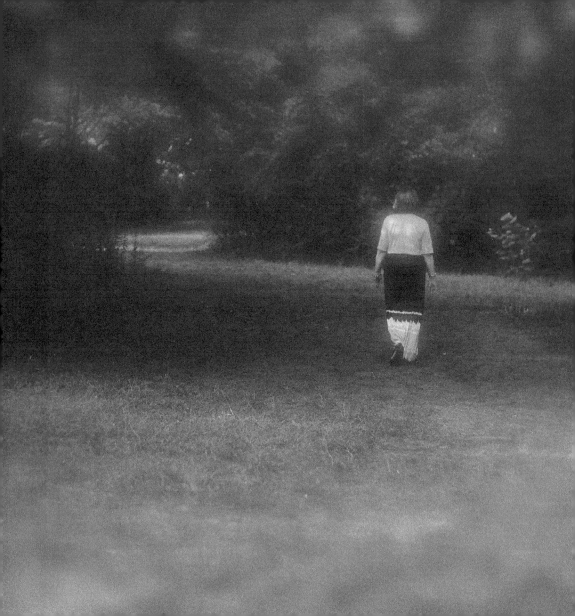

Sometimes on life's path,

we have light only

for the moment. It is a reminder

that it is the present

that needs attention.

Light for the next step

will appear when

we are ready.

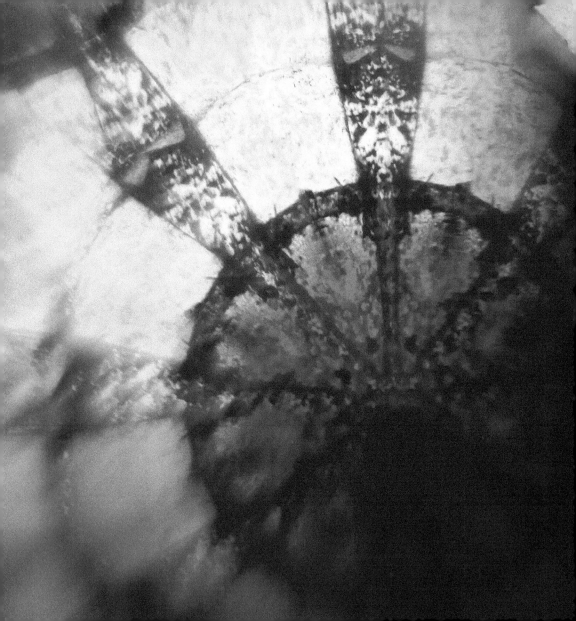

A mosaic is created

from broken pieces of glass

to form a beautiful work

of art. In the same way,

we are fashioned from fragments

of our broken experiences

that can design our life's masterpiece.

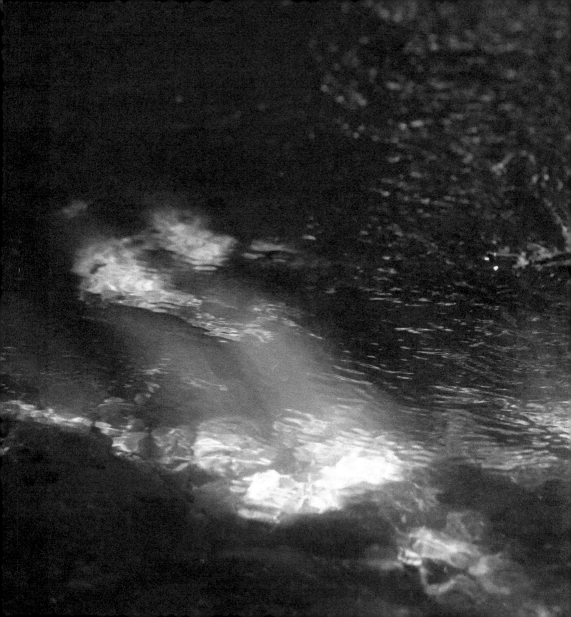

May the light

you need for your path

be the grace that finds

you today.

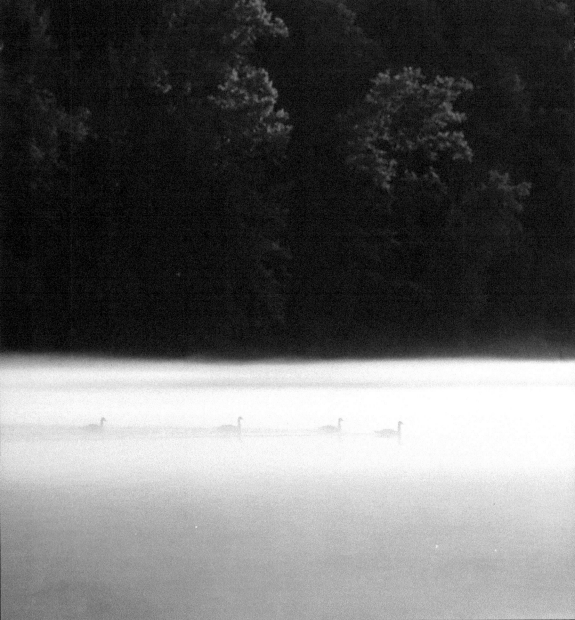

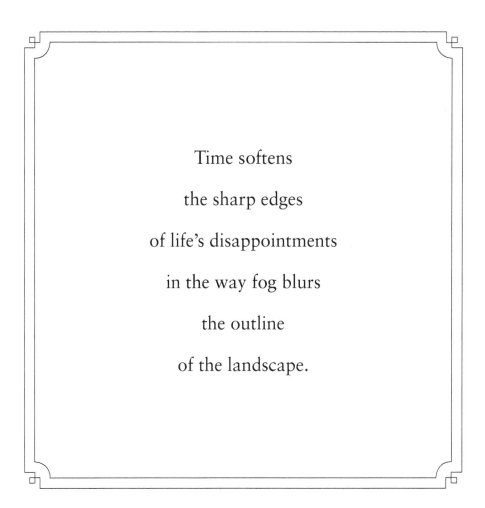

Time softens

the sharp edges

of life's disappointments

in the way fog blurs

the outline

of the landscape.

Like a pearl waiting

for discovery within the shell,

truth is often realized

between dreams of the night

and the soft light of dawn.

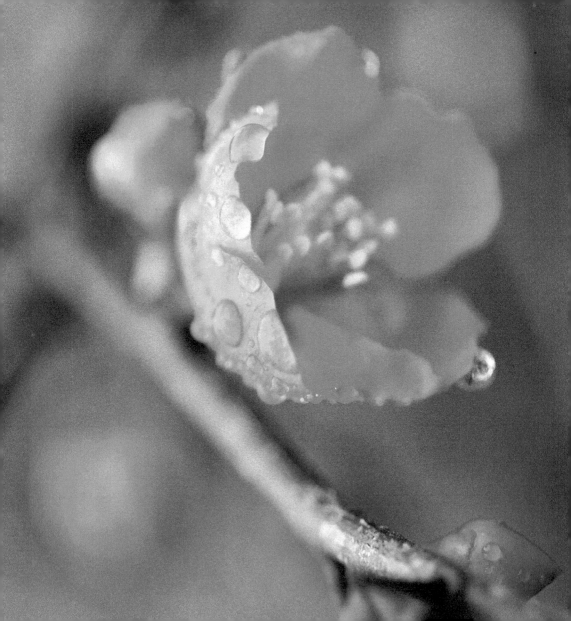

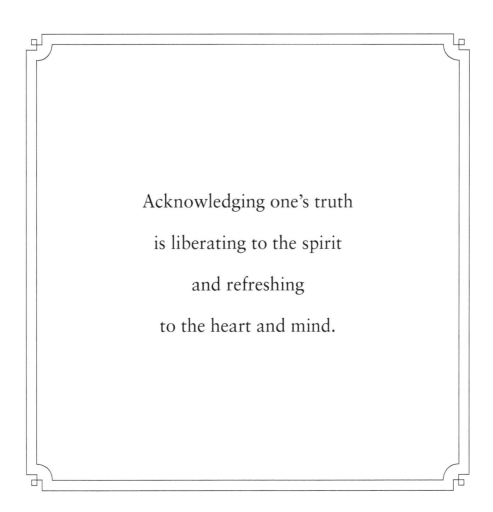

Acknowledging one's truth

is liberating to the spirit

and refreshing

to the heart and mind.

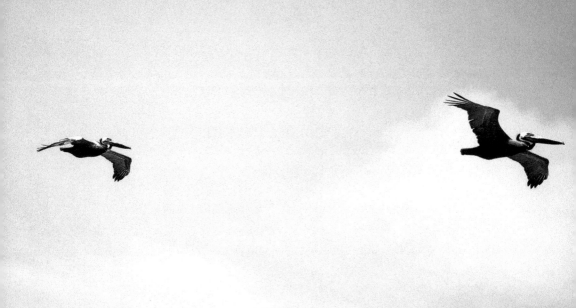

The light of dawn

brings a new day,

free from yesterday's

disappointments,

offering one more chance

to get it right.

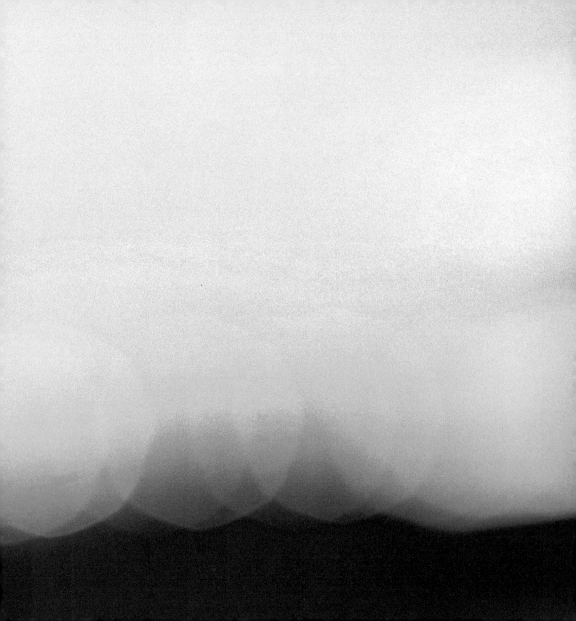

Practicing staying

in the moment teaches

me to accept the peaceful

and beautiful ambiguity of my life.

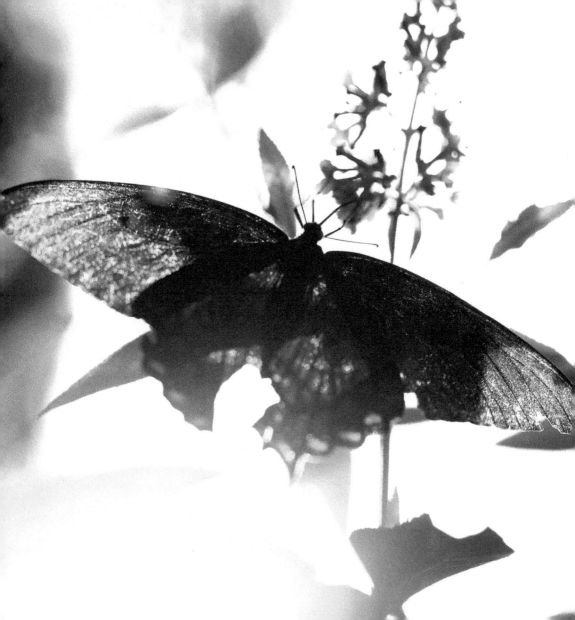

Our memories creep

in on silent wings as soft

and soothing as the shadows

from the setting sun

and then fly away again

as quietly as they came.

New beginnings allow

you to choose what to take

with you and what

to leave behind.

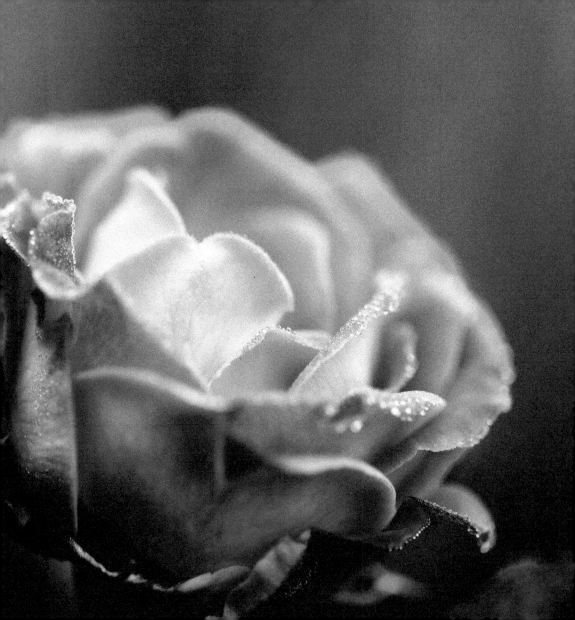

A life lived from a place

of pure intentions for every

action frees the heart

and mind from regret.

May warmth and love

wrap you in comfort

the way flames

in the fireplace drape

themselves caressingly

around the source of their light.

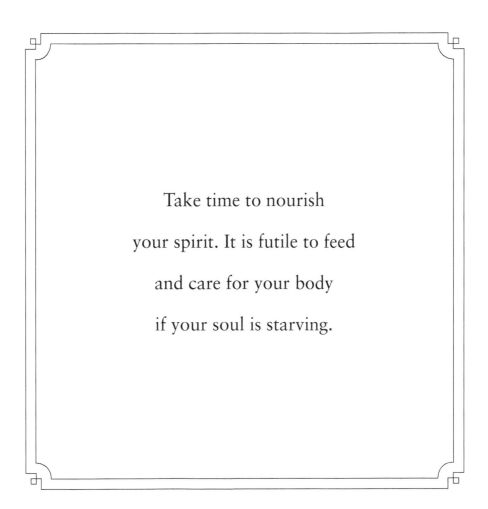

Take time to nourish

your spirit. It is futile to feed

and care for your body

if your soul is starving.

Sometimes the most comforting

thing to offer someone

who is grieving

is our silent nearness.

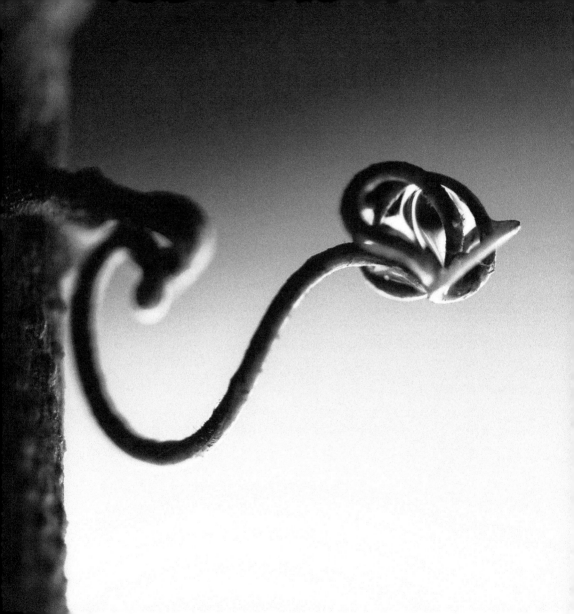

Poetry is the voice

of the heart,

and the poet

holds the key

that unlocks it.

May you always have

the courage to choose

a new path if you find

the one you're on

is taking you

in the wrong direction.

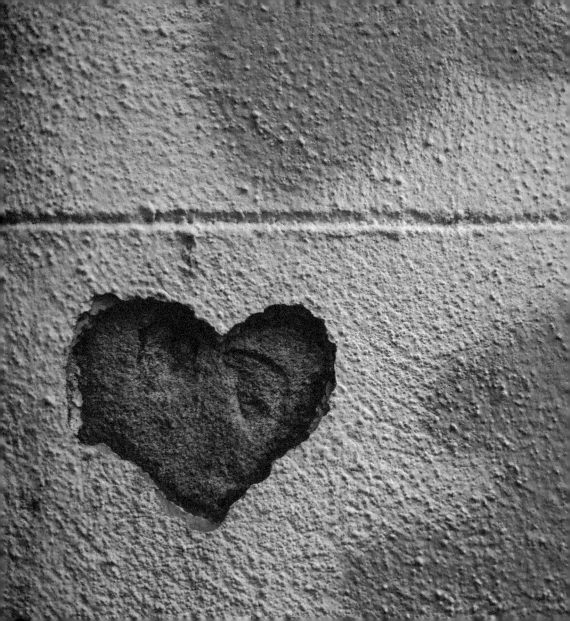

The heart has an endless

capacity to love,

even when it gets broken.

And like an eternal stream

within a mountain,

we can never use it up

as long as our heart

remains open.

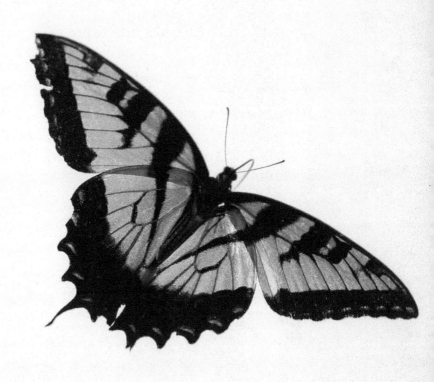

The serenity of quiet moments

allows space to explore

untethered thoughts.

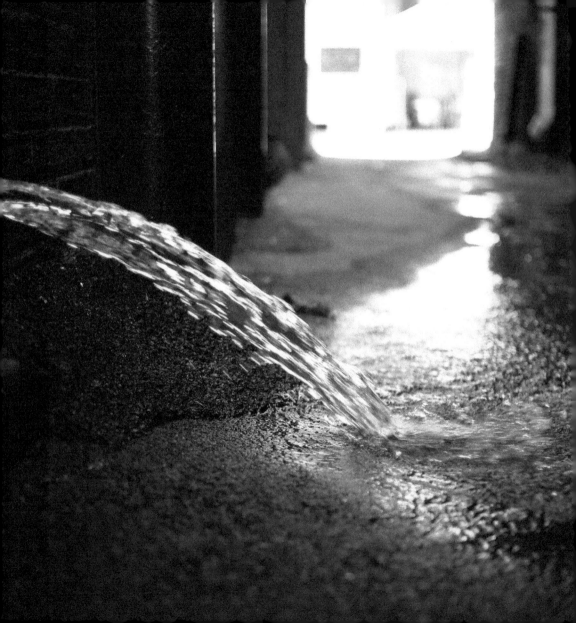

Thoughts are a powerful

force that can propel us

forward into joy or take us

into the depths of despair.

Be aware of which

thoughts you choose.

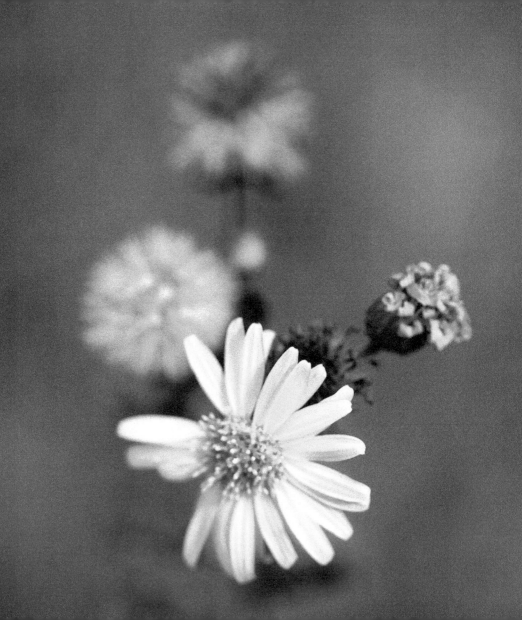

It is easy to become

complacent and think

there will always be time

to do the important things,

forgetting that this moment

is the most valuable

of our lives.

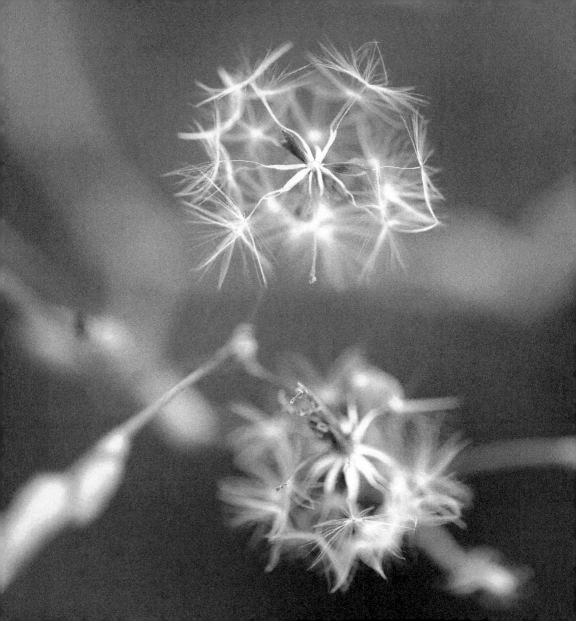

My wish for you

is that you will always

have the comfort you need

to renew your spirit.

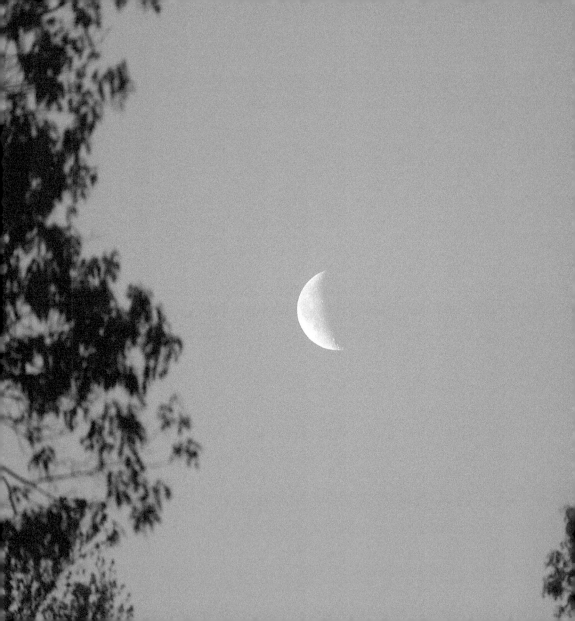

To stand under

a moonlit sky in the silence

of early morning is to know both

joy and peace as I enter

the grace of another day.

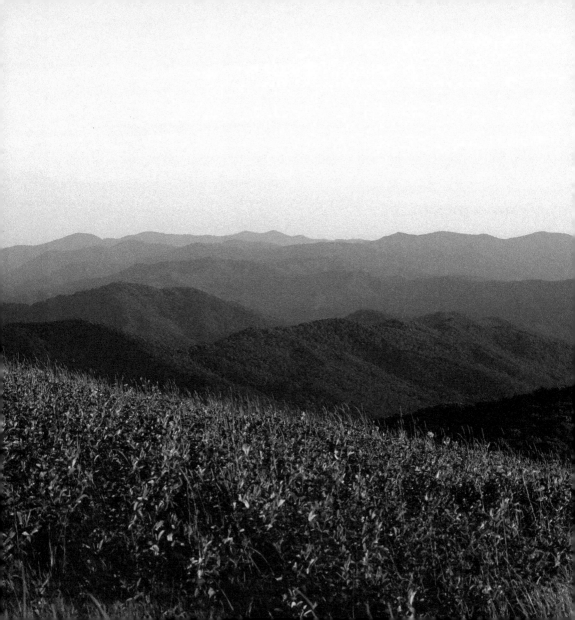

When I face life

with courage, I give myself

the power of hope and choice.

Without it, I become stuck

in situations that block

the wisdom within

when I need it most.

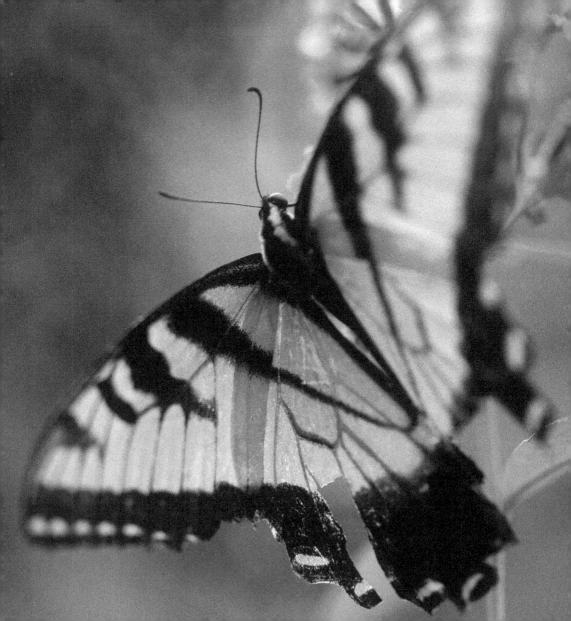

While I was distracted

by life, the joy of it

almost got away.

I will not make

that mistake today.

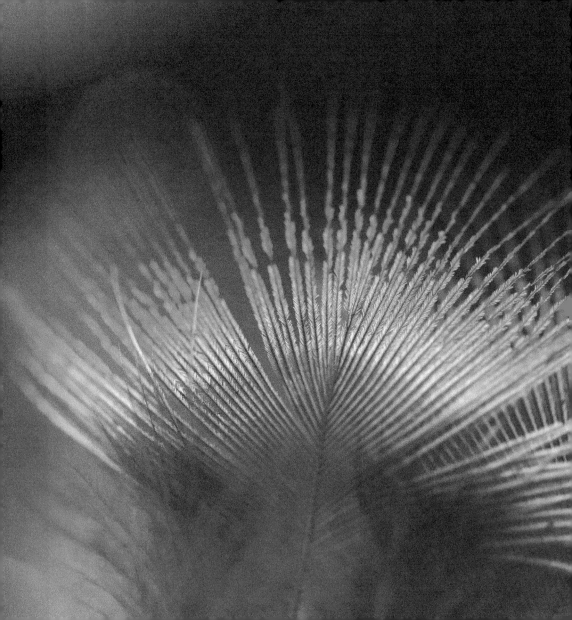

Joy is pain embraced

and put to work

in creative expression.

Today, I will open my heart

to the pain I have denied

and allow that feeling

to guide my pen

toward acceptance

of all my experiences.

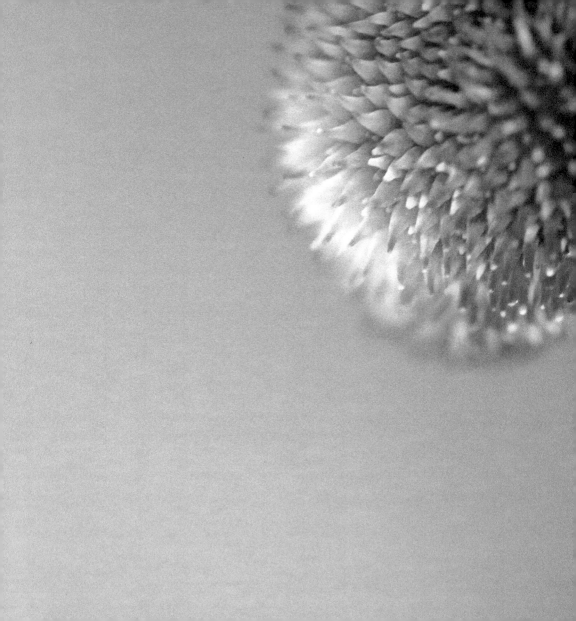

When I am

in that space between

what was and what is

yet to be, I have learned

to pay attention to the soft

whispers of possibilities

within my soul.

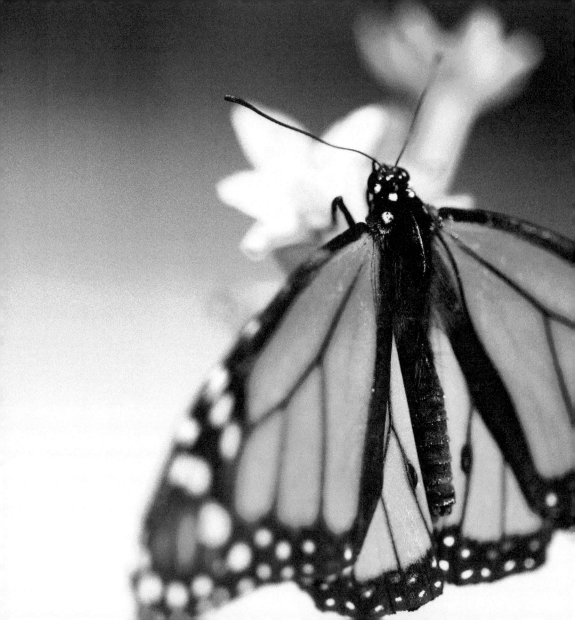

When I stopped clinging

to the idea of what I wanted

my life to be, I found myself

at the joyful center

of what it is.

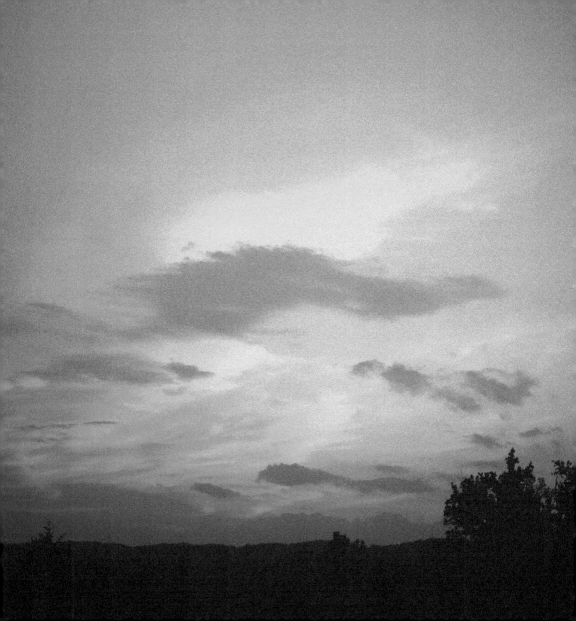

The dawn of each day

is like a blank canvas.

You can paint whatever

you want there, but you won't

have this particular canvas again.

Strive to make

each day your masterpiece.

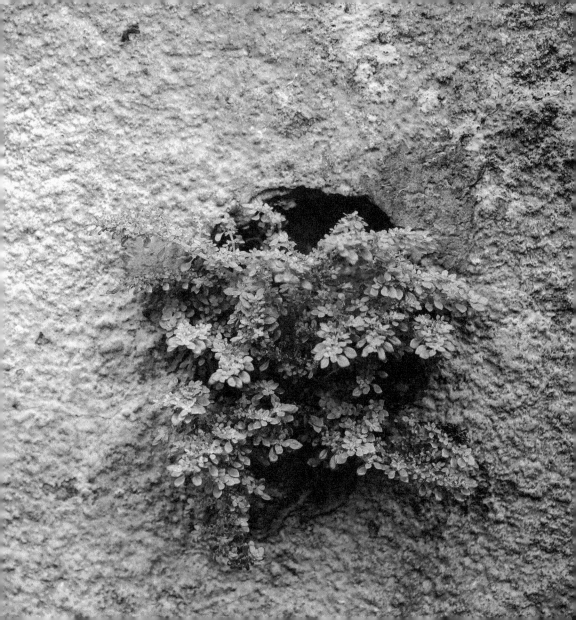

What if you knew

that today was all you have?

What would you do?

What are you waiting for?

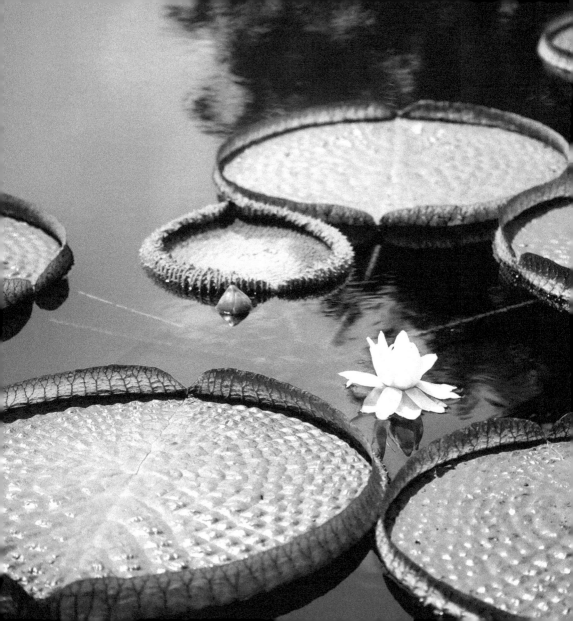

Stillness of mind

allows the soul

to hear and speak

its wisdom.

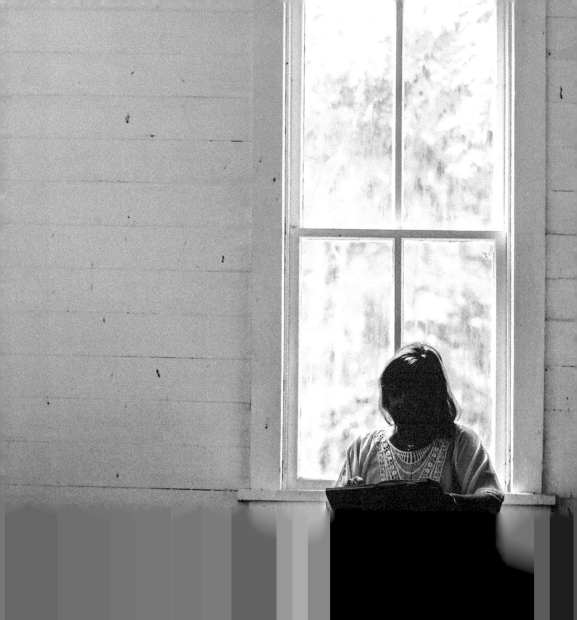

With each word

I write, I uncover

the wisdom within

my soul, one word

at a time.

ACKNOWLEDGEMENTS

There are many people to acknowledge for supporting this project. I am grateful to all who have been part of *Soul Whispers: Listening to the Wisdom Within*.

As I transitioned from employee to writer, the Tennessee Mountain Writers helped me make that leap. Their annual conference offers workshops and lectures from authors, publishers, and teachers who share their experience and knowledge. I am appreciative of the educational offerings that help improve my craft and for the awards for my inspirational prose.

I am also grateful to the Writers of Grace for selecting one of my essays for inclusion in the 2017 anthology, *In God's Hand*. I am honored to have my writing included with that of the talented authors and poets whose work makes up this anthology.

While I value the support to my writing, it is to Jim Johnston that I owe gratitude for instilling the vision of publication. I met Jim before the sale of, and his subsequent retirement from, Celtic Cat Publishing, which he founded. He had read a collection of my essays and, while he was no longer accepting submissions, he enthusiastically encouraged me to publish my work, giving me the courage to take a risk.

The photos within *Soul Whispers* are by photographer Stefanie Stair. I am appreciative of her acceptance of my commission to provide images that reflectively enhance the meaning of each verse.

To Katherine Bumgardner, my best friend, my cheerleader, and my prop when I doubted myself, I am forever grateful for her unwavering support every step along the way.

To Patricia Hope, her tireless efforts in editing and developing initial layout ideas for the material in this book became the encouragement that inspired my transition from employee to author.

To those whose support facilitated the final steps to completion, I owe special thanks. To Reverend Randy Griffis, I am grateful for his assistance in examining my assertions from a spiritual context; to the authors and teachers for their graciousness in offering reviews and book blurbs; to Helen Mullins for her creative presentation concepts and Beto Cumming for purity and beauty in cover and book design.

Finally, to my Ohio friends, I left a part of my heart with you when I resigned my job in Piketon. I am forever grateful for your acceptance and support of my work, then and now, especially for that of my boss and coworkers. Without it, this book would still be just an idea.

About the Cover Photo

The author chose a photo of the Blue Ridge Mountain Range from her private collection as the cover of *Soul Whispers: Listening to the Wisdom Within* because it beautifully represents her Appalachian heritage.

She began life in a cabin converted from a corn crib on her grandfather's farm in the mountains of Greene County, Tennessee. The cemetery visible in the photo is on the grounds of River Hill United Methodist Church on Old Asheville Highway. When her grandparents and great-grandparents attended there, the church was known as River Hill United Brethren Church.

The gravesites of the author's paternal great-grandparents and other family members of their generation are in that cemetery. Her grandparents and parents lived nearby, where her grandfather was a sharecropper. He later bought land a few miles away, and this farm is the location of the corn crib, her first home. She is the eighth generation born in this region and still lives in the Southern Appalachian area of East Tennessee.

Visit her website at www.barbarajturner.com and follow her on social media to learn more.

Praise for *SoulWhispers*

Barbara Turner embodies the wisdom and knowing of the Sacred Feminine. With a stunningly expressive gift for language, she is an eloquent messenger for Divine Will and Love, a spokeswoman for the Holy. These poems call to our hearts in the spirit of Rumi, Khalil Gibran—but with a transcendent twist for the twenty-first century. She is a prophet—as Woman.

> —Sara Xochitl Griscom, spiritual teacher/owner, Sacred Feminine Shamanism™

In her insightful collection, *Soul Whispers: Listening to the Wisdom Within*, Barbara Turner speaks to the healing power of a contemplative life, one where we *make* time to be still, to reflect, to listen.

> —Jim Johnston, author of *The Price of Peace* and *Exile Revisited*

It is obvious that the passion with which Barbara Turner writes is not just a reflection of a life that has always worked out as hoped, but reflects the depth and sincerity of someone who has had to find a way to deal with life when it brings challenges and suffering. I have yet to read one of her poems or essays without feeling she has the talent and compassion to change people's lives for the better. Her writing is full of unconditional love and truth. I don't think she knows it yet, but she is a prophet. Her words are not just to be read in the future after her death, but are to be read now, by those who are living and trying to learn how to give love and to accept love.

> —Lawrence Long, composer/guitarist/teacher,
> and founder of Knoxville Guitar Society

CPSIA information can be obtained
at www.ICGtesting.com
Printed in the USA
LVHW052104280619
622709LV00002B/2/P